THE PHOTOGRAPHS OF KIRK GITTINGS
SHELTER FROM THE STORM

BY GUSSIE FAUNTLEROY
ESSAY BY V.B. PRICE

Photographer: Kirk Gittings
Author: Gussie Fauntleroy
Editor: Emily Drabanski
Book Design and Production: Bette Brodsky
Publisher: Ethel Hess

Library of Congress Control Number:
2005920000
ISBN: 0-937206-84-9

Printed in China

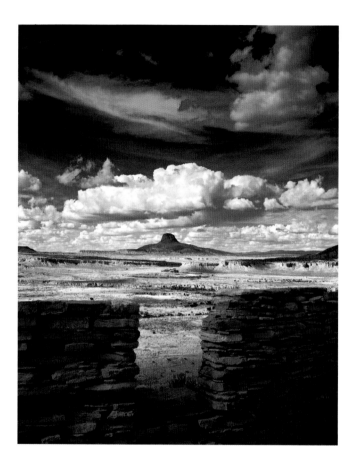

TABLE OF CONTENTS

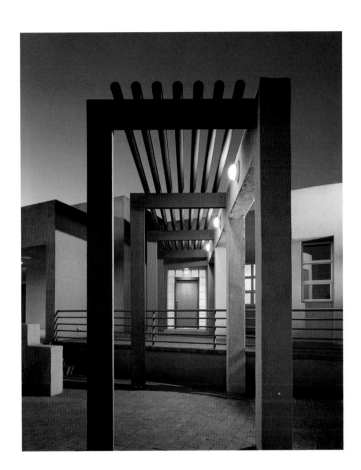

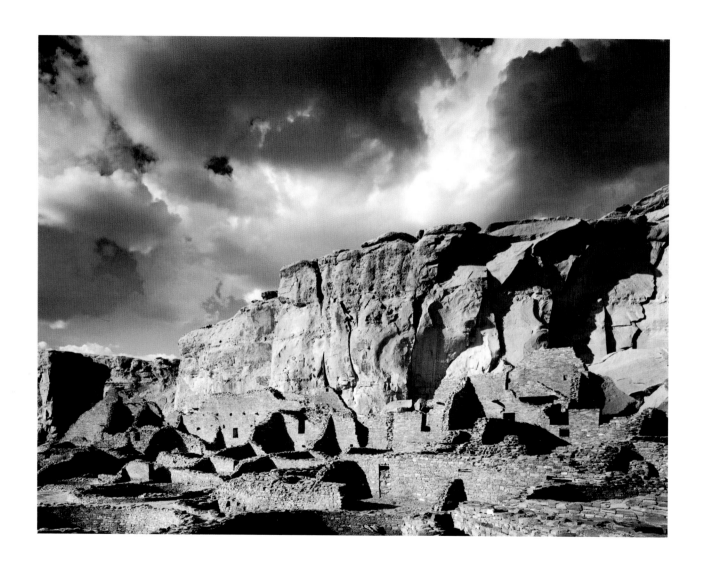

Foreword

This was the first of many adventures in the canyon as we worked on a book of his photographs and my poems that became *Chaco Body*.

In its introduction, we wrote, "Without knowing each other, or having any idea that someone else might share our feelings and intuitions about the spiritual landscapes of the Chaco wilderness, we had both developed private mythologies about our relationship to the canyon. They proved to be uncannily similar.... . Chaco became for us a talisman of renewal and metamorphosis. To go there was to be spiritually reconnected with the energizing power of the flow of time and the symbolic drama of light, air, artifacts and land."

I'd been drawn to Chaco since the early 1960s. But it was only at Kirk's invitation, and after I saw his photographs, that I considered making poems about the canyon. It was a turning point in my creative life. The sense of shared sensibility and imagination between us was unique to my experience and remains so. Kirk's enthusiasm and attentiveness have a catalyzing power. He photographs the meaning and the emotional essence of what he sees, while still reflecting the actuality of the landscape. The light of revelation in his photographs has given me, and many others, an access to the

soul of Chaco Canyon that we can absorb through the matrix of our own experience.

The focus and devotion of Kirk's attentiveness embraces modern and historic architecture as well as sacred sites such as Chaco Canyon. For more than 30 years as a photographer, Kirk has followed a spiritual practice of opening himself to the intimate realities of a field of vision, a spiritual landscape that he first encountered as a boy roaming the harsh and isolated desert countryside of Albuquerque's West Mesa. His father worked at an Air Force radar station there during the Cold War. It was in that empty place, with its heroic views of the Sandia Mountains, that Kirk became a self-described "desert rat." Even as an adolescent, he liked "to see long distances and how the shadows of clouds break up a landscape." The West Mesa "might seem like a wasteland to some, with absolutely nothing to do, but I was never bored. I was never indoors, I was out exploring ruins, tracking critters. That landscape was full.... . I have few memories of any places in my childhood but there."

As he wrote recently in a statement for a retrospective exhibition of his work in Louisville, Ky., "Ever since I was a child...I have always found the greatest sense of presence in

abandoned and unpopulated places... . It is a great irony to me that places that feel so desperately lonely are where I feel most alive."

It's possible to describe Kirk Gittings as a spiritual or metaphysical photographer, one who gets to the transcendent being of a place. It's equally possible to describe him as an environmental or landscape photographer, because even when he's working with contemporary architecture, his photographs are of structures in the context of specific places. It's that quality in his work of being situated in reality, even in his more ethereal images, that grounds his imagination in authenticity.

I've always marveled at how Kirk's photographs of human structures—be they archaeological ruins, old New Mexico churches, remnants of a lost industrial landscape, or the most contemporary architecture—convey with such rational clarity his emotionally enthusiastic and loving respect for the world. The exacting detail he brings to his photographs of buildings, combined with his intuitive openness to the "patina" of meaning hidden in their forms, allow viewers to partake of this mysterious and intimate exchange between photographer and subject for themselves. From his perspective, it seems, human structures are a part of nature, and they, like the humans who create them, share in the majesty of the world's fathomless beauty.

The portfolios in this book reveal Kirk's unifying devotion to seeing through the illusions of inattentiveness to find the heart and soul in the truth of experience—that everything has an irreplaceable presence, a unique essence, however fleeting or without interest it might seem. Kirk's photographs show us the world as it is to itself, a continuous flow of moments that we can apprehend if our minds and hearts are open to their meaning and their splendor.

– V.B. Price
Albuquerque, N.M., August, 2004

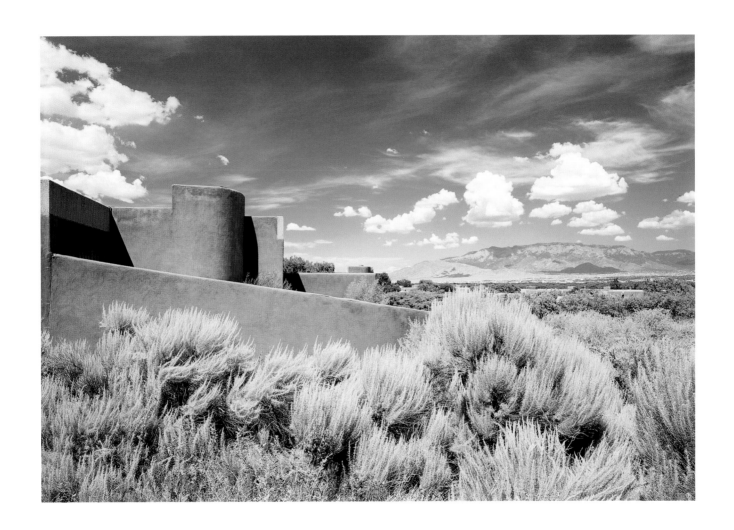

7

Mystery and Meaning

IN ITS LANDSCAPE AND ARCHITECTURE, NEW MEXICO IS A PLACE LAYERED WITH MEANING, ANIMATED BY THE POWERFUL PRESENCE OF THE PAST. LIKE ENTRANCEWAYS FRAMING DEEPER DOORWAYS, CONTEMPORARY STRUCTURES ECHO THE FORMS OF EARLIER EDIFICES BUILT BY HAND FROM MUD AND STONE, THE MATERIALS OFFERED BY THIS HIGH DESERT LAND.

In turn, these centuries-old structures, sanctuaries of spiritual and family shelter, echo an even deeper past, a time when the embrace of earth and sky was an integral part of daily life. To be aware of these layers of meaning is to see the continuum of New Mexico's rich history within a simple architectural element—the end of a *viga*, for example, as it projects from an exterior wall.

Kirk Gittings has long been intrigued by hidden treasure, secret meaning and mystery—the rewards of looking beneath the surface. Since boyhood, he has gathered experiences and tools that allow him to lend us his eyes so we might see some of these things as well. Born in 1950 to an Army radar technician (who later transferred to the Air Force) stationed in Alaska, Gittings spent his childhood in isolated, exceptionally beautiful landscapes—the wilds of Alaska, the coast of Maine and the expanse of high desert central New Mexico terrain. At the age of nine he and his brother Kent were exploring ancient Indian ruins and petroglyph-covered volcanic rock walls.

Gittings studied photography and art history at the University of New Mexico in Albuquerque, acquiring his first large-format camera in 1978. Between UNM and graduate school, he took a break from the camera, immersing himself in less solitary aspects of northern New Mexico life as a Volkswagen mechanic, welder and Vista volunteer in the village of Tierra Amarilla. On weekends he hung out with the post-hippie crowd in Taos. When it was time to return to his true passion, he earned an MFA in photography from the University of Calgary, in Alberta, Canada. Drawn back to the Land of Enchantment, Gittings focused on the monumental ruins at Chaco Canyon Cultural National Park in northeastern New Mexico as his earliest important photographic subject. He immersed himself in this place where ancient Ancestral Puebloan stone structures and the very canyon walls are imbued with the presence of a powerful spiritual past. The experience helped establish his aesthetic vision and eventually resulted in a book, *Chaco Body*, with poetry by V.B. Price. Back in Albuquerque following graduate school, the photographer considered possible careers in which he could use the large-format equipment and skills he'd been mastering. After 12 years' experience in what was essentially architectural photography at Chaco Canyon, he decided to turn his viewfinder in the direction of contemporary architecture. It proved to be a fortuitous choice.

In the past 20 years, Gittings has earned a wide reputation for his astute and sensitive photographic interpretations of New Mexican architecture. Riding the

ongoing wave of interest in Southwestern design and style, he has worked primarily in his home state, while his award-winning photography has been published in magazines and books on architecture and other subjects, nationally and around the world. For many years he has taught photography as well, as an adjunct professor at the University of New Mexico, a visiting artist and instructor at the School of the Art Institute of Chicago and at photographic workshops. In addition, as an articulate and thoughtful writer, Gittings has contributed articles on photographic technique and aesthetics to many periodicals, including *View Camera Magazine, Camera Arts Magazine* and the *Journal of American Photography.* He continues to use an all-manual, 50-year-old Calumet wide-field 4x5 camera for architectural work and a 20-year-old Zone VI (4x5) field camera for landscapes. "Pickier than the average photographer," he does virtually all his own printing, both in color and black-and-white.

As he travels around New Mexico on commercial shoots, Gittings takes advantage of the opportunity to experience and photograph the state's extraordinary landscapes and architecture for his fine art portfolio as well. Among the structures—often aging and sometimes abandoned—that ignite his imagination are churches and chapels. His photographs capture these repositories of faith and spirit where human aspirations, hope and humility speak in a timeless, wordless language through the architecture itself.

As the images in this book reveal, there is a coherence in Gittings' sensibility, vision and style that runs through both his commercial and fine art photography. From ancient to ultra-modern, the architecture of New Mexico—rooted in the earth, graced by the craftsman's hand and offering a sense of continuity in materials and form—has much to tell about who we have been and who we are. "There's something about continuity that embodies a kind of hope of progress for mankind, and there's an implied hope in aesthetic beauty," Gittings reflects. "That's part of what I try to do with photography—to share this sense of order and hope and meaning and mystery."

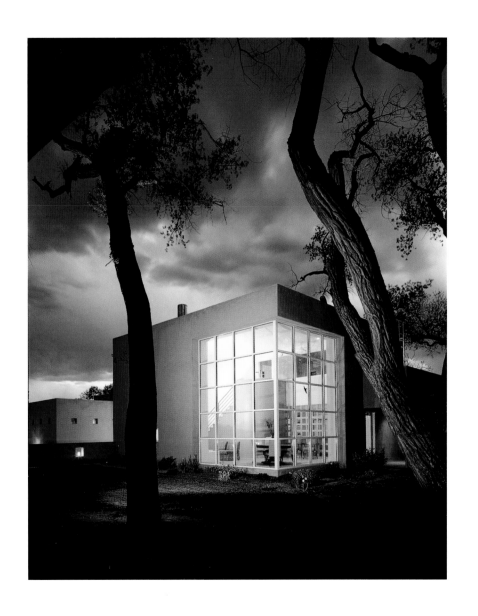

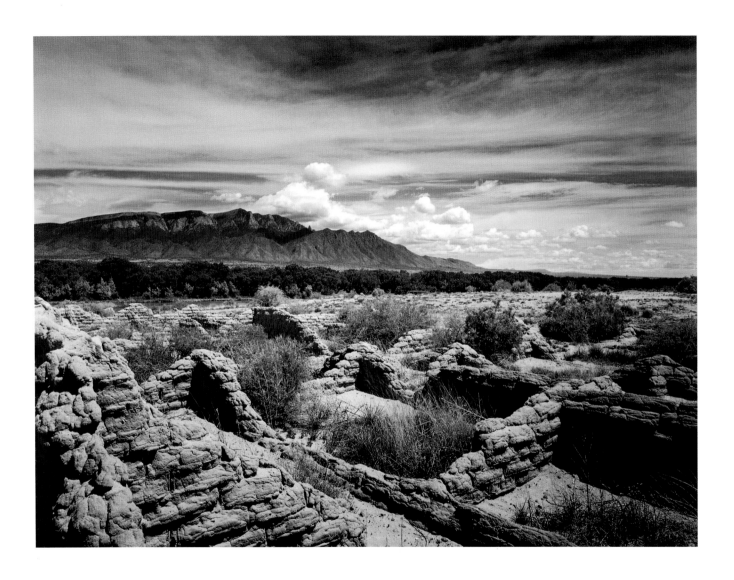

Ancient Forms Return to the Earth

IN THE "MYTHOLOGICAL LANDSCAPE," AS GITTINGS CALLS IT, THE VERY EARTH AND AIR SEEM, PARADOXICALLY, BOTH DEEPLY QUIET AND VIBRANTLY ALIVE WITH THE SPIRIT OF PEOPLE FROM A LONG-AGO PAST.

Human hands—calloused, strong and sun-browned, no doubt—carried and carefully laid stone upon stone in what would become sturdy shelter for families, storage rooms for food, sacred spaces for prayer and spiritual instruction. In early Puebloan cultures reaching back to the 9th century, the architect most likely was also astronomer, cosmologist, mathematician and holy man. He designed and oriented structures and entranceways in accordance with sacred and celestial law. Generations of experience with materials of the earth were passed down to the builders, whose patience and skill went into each row of stone or block of sun-hardened clay.

Over a period of 12 years, beginning in the late 1970s, Gittings spent much time absorbing and photographing the landscape and ancient architecture at Chaco Canyon, the most notable of early Puebloan societies in what is now New Mexico. The photographer was attracted to this place for its stark yet breathtaking natural beauty, as well as the mystery of the ruins that reveal immaculately designed and constructed structures. His experiences at Chaco also brought back favorite boyhood memories. With his older brother, young Kirk would spend hours engrossed in exploring and climbing over and around hilly mounds of eroded ruins near the Rio Puerco west of Albuquerque. His awareness of Native American blood in his own family enhanced his natural curiosity and fascination. Gittings learned from his father that an ancestor in the late 1700s, an Englishman who traded whiskey with North American Indians, married a Naraganset woman. Their half-Indian son, also a trader, traveled deep into the frontier. He married a woman of the Sauk and Fox tribes.

When Gittings photographs the remains of ancient structures at Chaco and elsewhere around the Southwest, their timeless presence is heightened by the use of black-and-white film. His images reveal the resemblance of slowly disintegrating forms to shapes in the landscape itself: Distant hills echo jutting remnants of walls, and circular chambers are open to the bowl of sky. Often, ruins appear to grow out of the earth that quietly reclaims them. This earth/sky embrace presents a metaphor for the concept of balanced duality that runs through the ancient American Indian world-view: the balance of female and male, material and intangible, earthly and the divine. Gittings' intuitive sense of timing gives us the visual counterparts to this: the stillness and physicality of stone against the drama of impending storm; the mystery of shadow and the clarity of light. The result, for the viewer, is beautiful imagery that powerfully opens a window to our past.

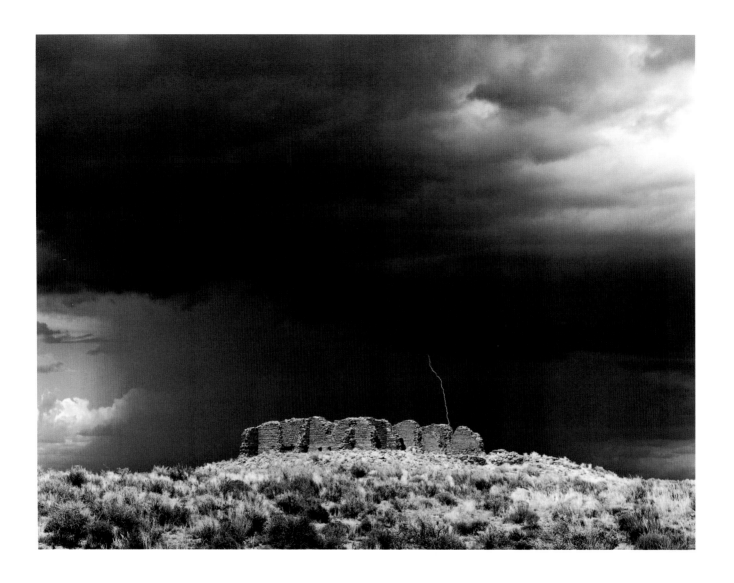

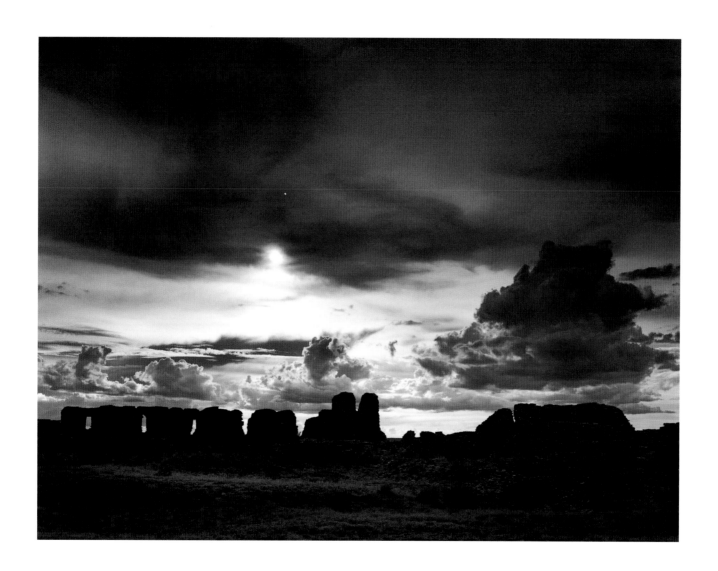

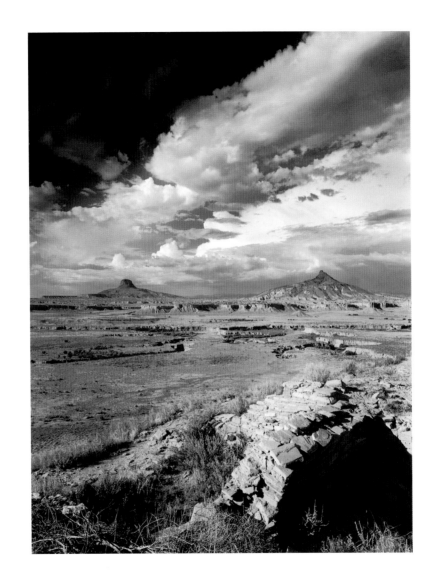

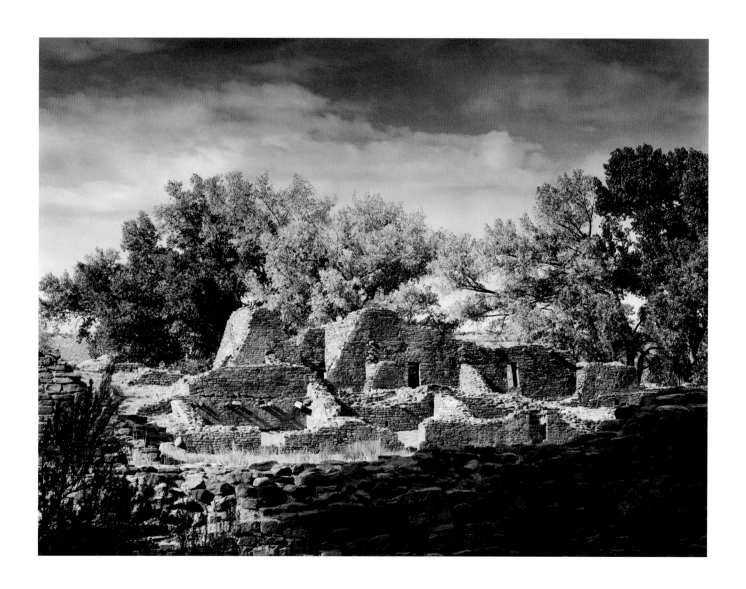

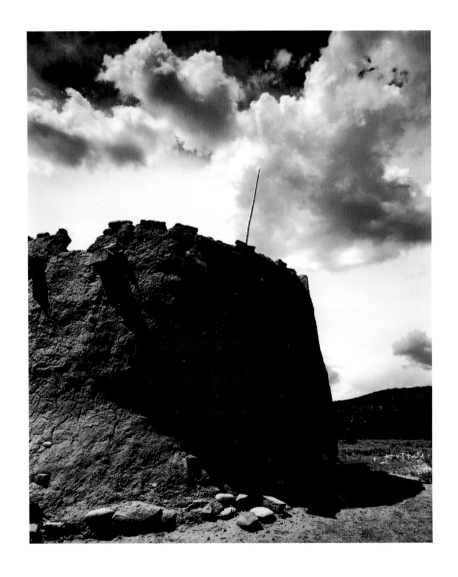

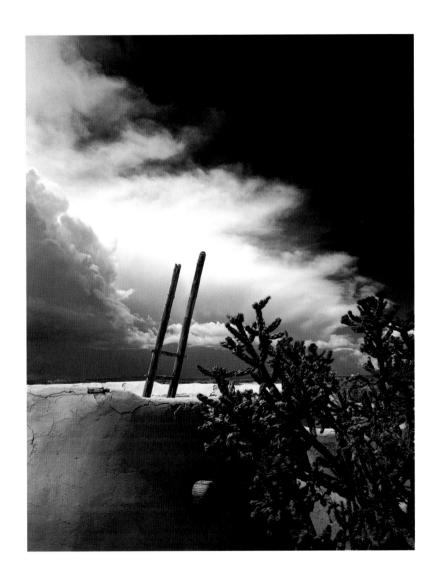

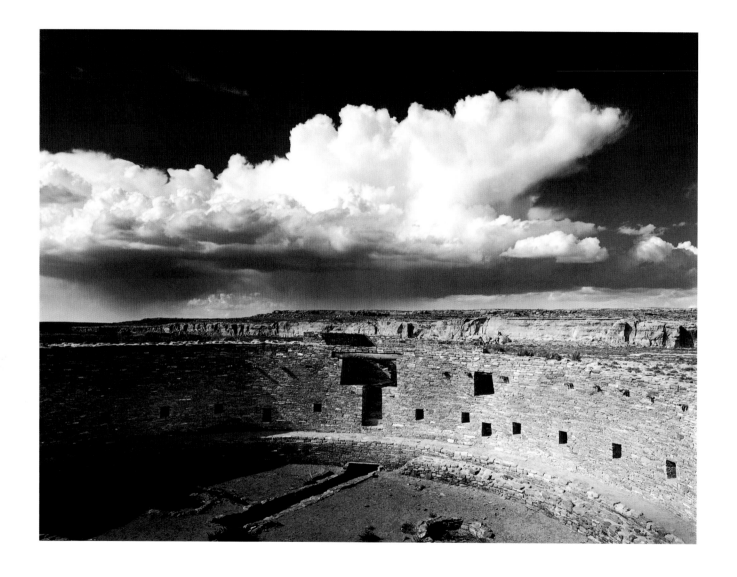

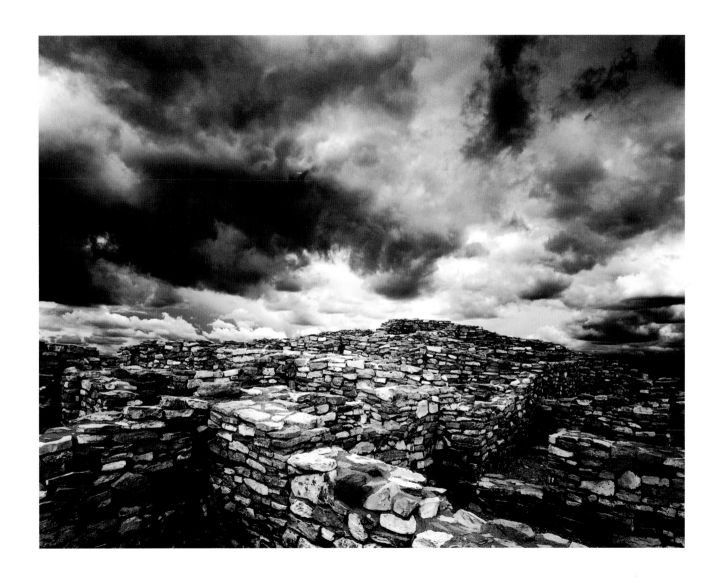

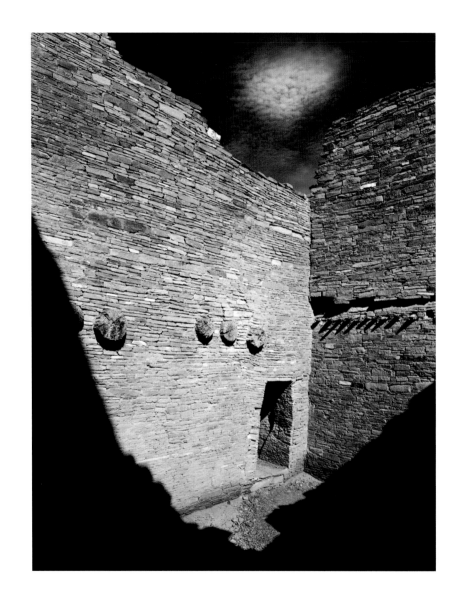

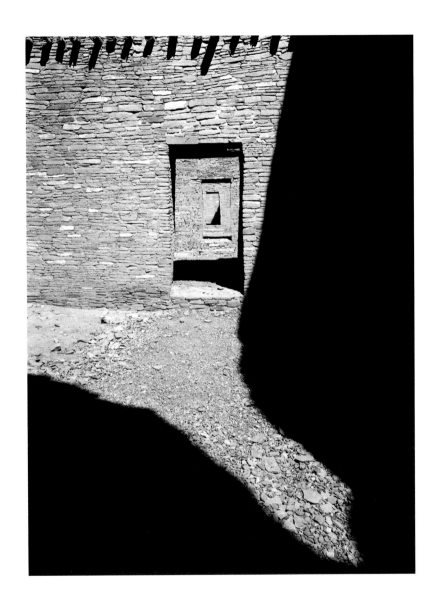

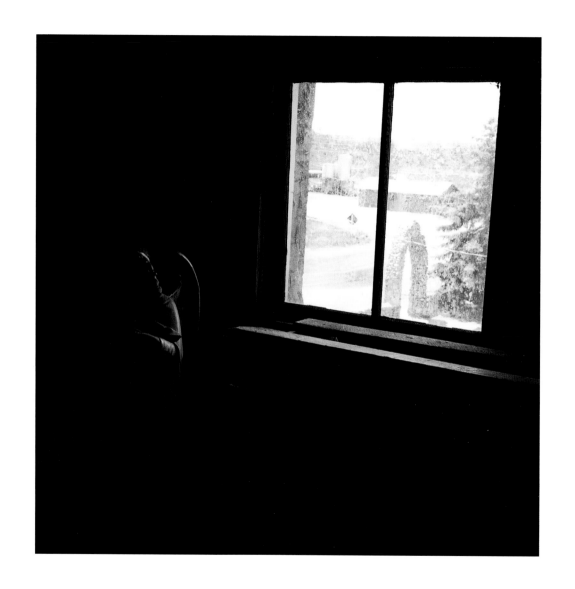

Enduring Forms of Faith

IN THE VILLAGE OF TRUCHAS, ON A HIGH PLATEAU IN THE MOUNTAINS OF NORTHERN NEW MEXICO, AN OLD ADOBE CHURCH REMAINS IN USE BY THE LOCAL FAITHFUL.

The church has never known electricity and has "200 years of candle wax on the floor," as Gittings describes it. This is the kind of place that breathes with the presence of the past. Aging, hand-built churches and chapels such as this, in all stages of ruin or restoration, are like sealed and timeless vessels. They contain every silent or softly uttered prayer, all the devotion, humble entreaty and hope found in each song and all the stillness that have filled them over the years. Gittings calls this feeling the "spiritual patina" of a structure, and his photographs reflect the enduring richness and quiet beauty within each place.

Like the sacred spaces of a more ancient past, these thick-walled earthen edifices provided shelter for the soul in a land whose untouched expanses and utter isolation could inspire both exaltation and fear. Each church was, and many continue to be, the heart of the community that surrounds it—the place of gathering, of communal celebration and sorrow. And in a centuries-old tradition, parishioners take responsibility for preservation of the church. The women often mix straw and mud, and with their hands apply fresh coats of mud plaster to the walls, talking and laughing as they work. Lovingly created adornments show the craftsman's hand inside: carved and painted altar screens, bultos (carved wooden figures of saints) and retablos (religious images painted on wood.) Outside, the muscular swell of buttresses and gently rounded adobe walls suggest both masculine and feminine traits, as did the Pueblo's earlier architecture with circular spaces and strong, straight walls. And like the ancient forms, historical structures often echo the shapes of mesas and mountain peaks.

For more than five years in the 1980s, Gittings focused his camera on northern New Mexico's churches, with the resultant images featured in an exhibition and book. While the pictures deliberately contain no people, during the process the photographer came to know individuals embodying the deep, pure faith that is the foundation of a church. Describing an unassuming Peñasco woman, for example, he speaks of being moved by a "consuming and transcendent" expression of Catholic belief. "The world was spiritually alive for her," he remembers. "Every part of her life had prayer integrated into it." Reflecting this in visual form, Gittings' photographs reveal an architecture that continues to retain a quiet dignity, a sense of the reverence with which these structures were built and used—even as those not preserved begin to melt back into the earth.

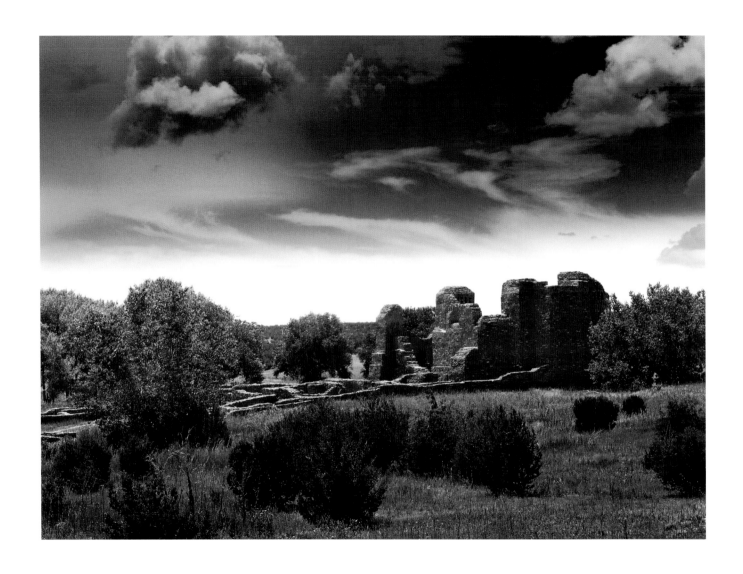

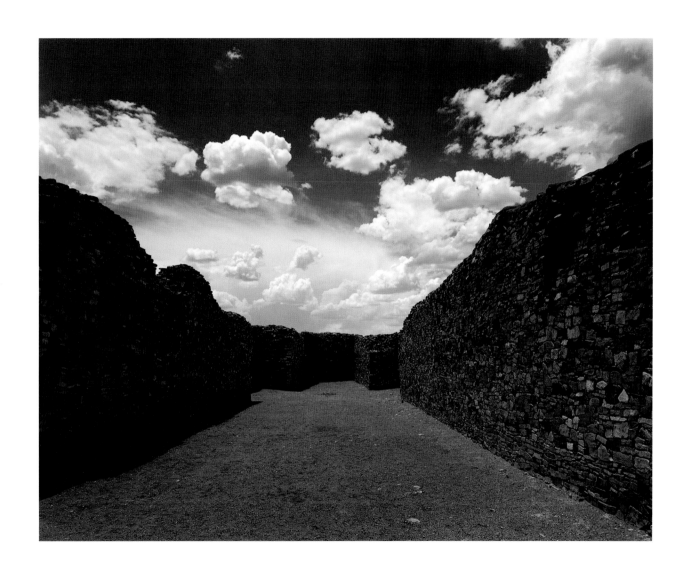

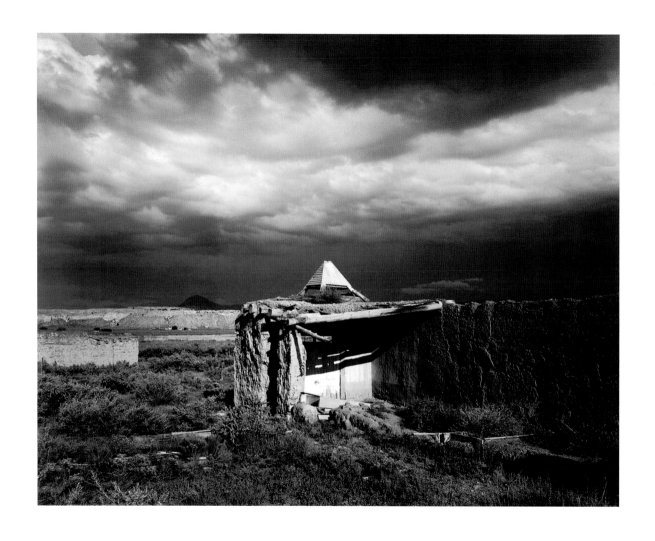

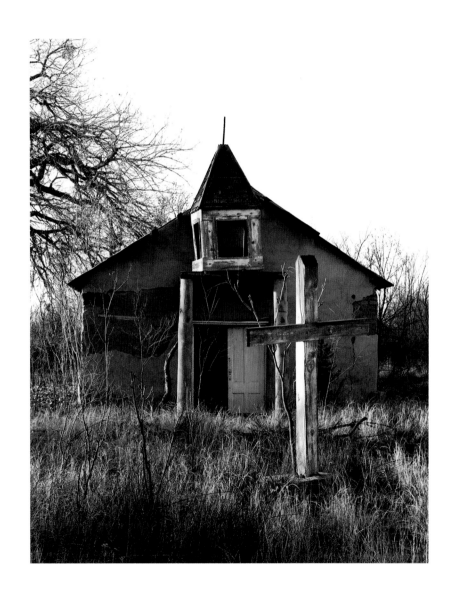

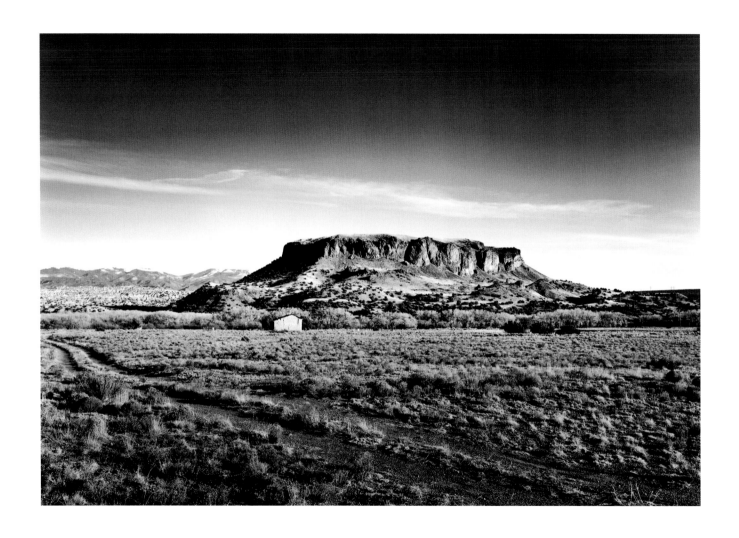

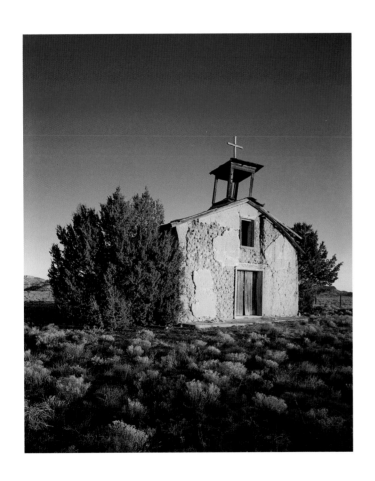

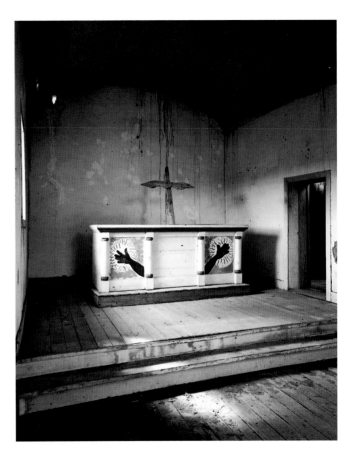

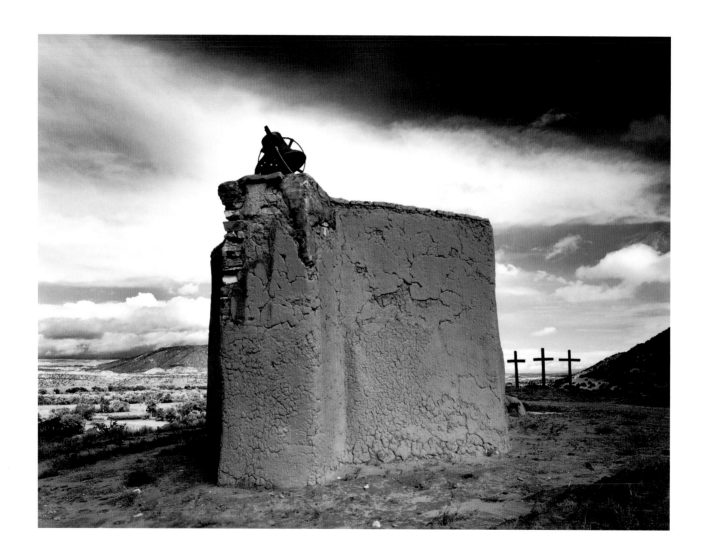

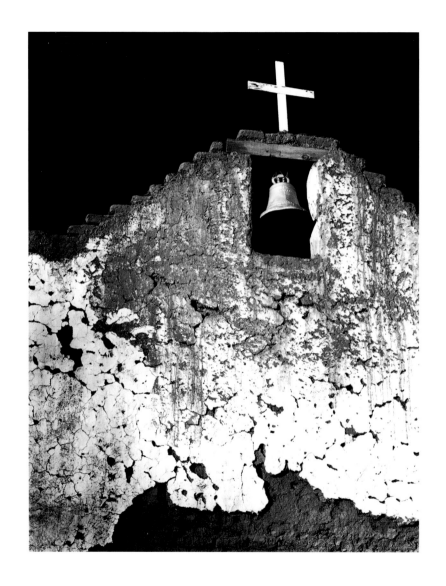

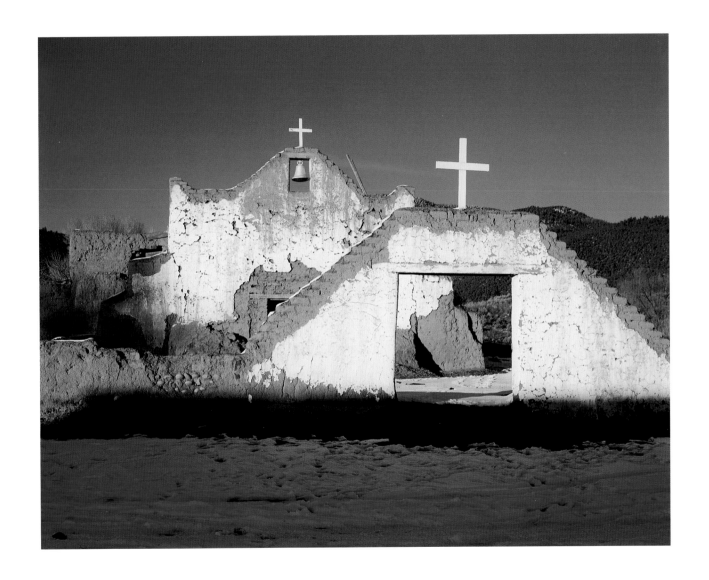

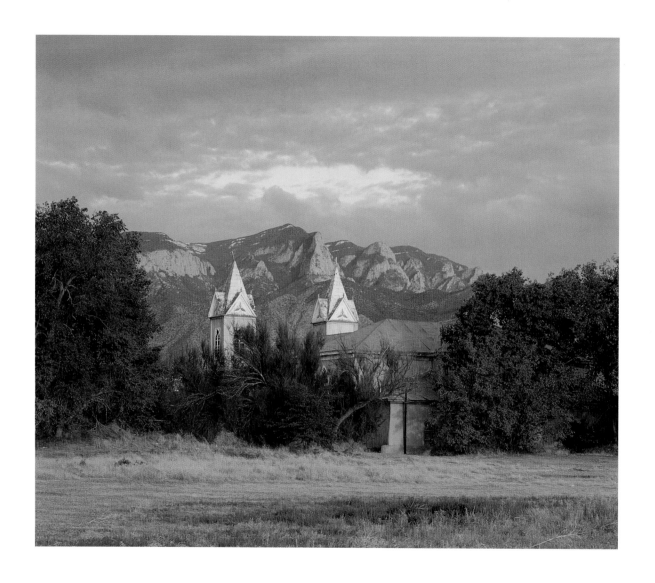

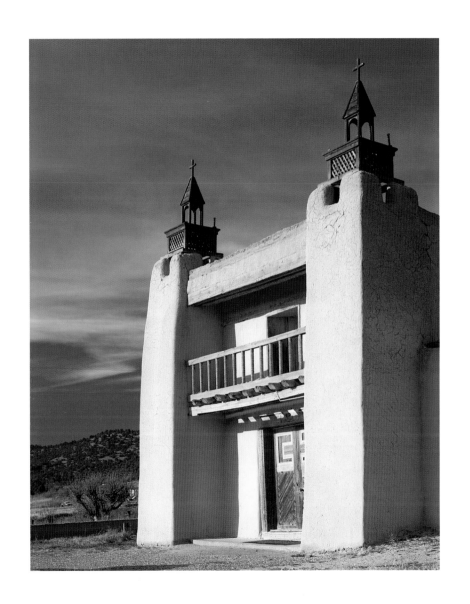

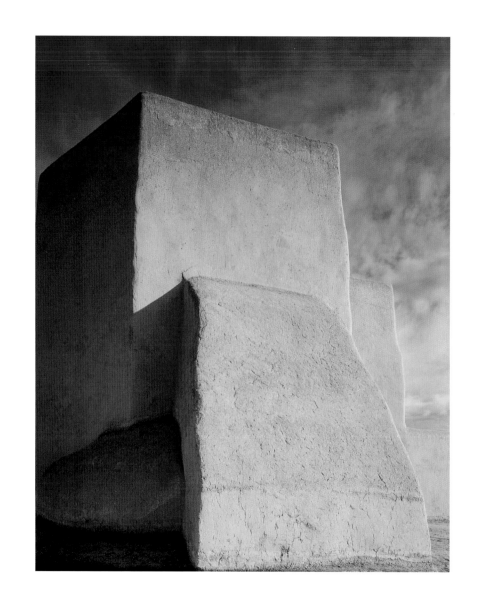

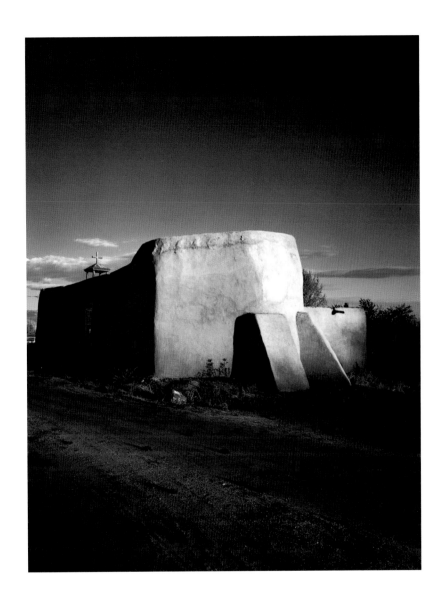

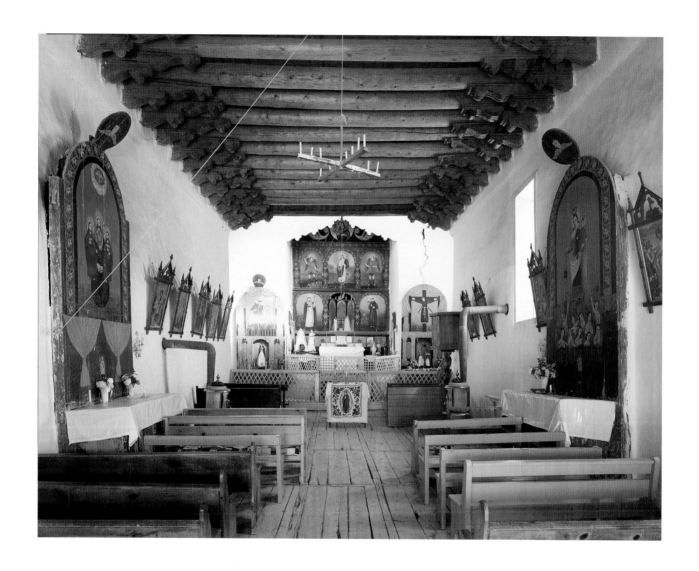

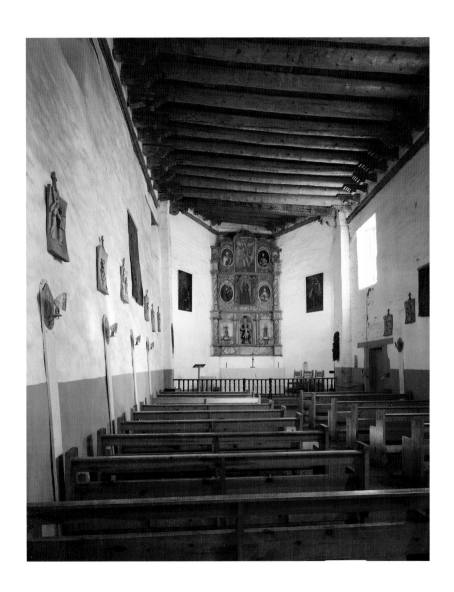

11

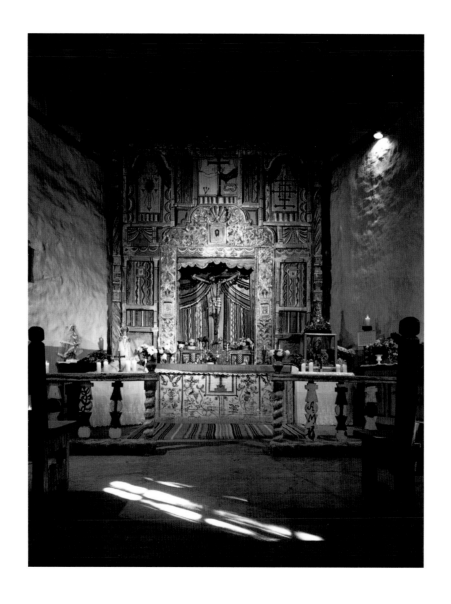

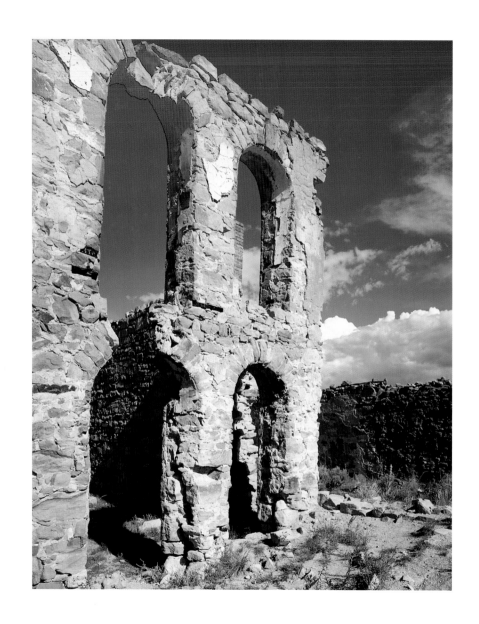

A Gracious Past

NOT ALL ARCHITECTURE IN NEW MEXICO IS ADOBE, NOR IS IT ALL PUEBLO STYLE. AFTER THE ARRIVAL OF THE RAILROAD IN THE 1880S, IN FACT, BRICK VICTORIAN HOMES AND SHOPS BECAME COMMON IN ALBUQUERQUE, LAS VEGAS AND SANTA FE.

That is, until early 20th century Santa Fe boosters decided their town should have its own distinct identity and began to promote the low-rise, flat-roofed, brown-stuccoed Santa Fe Style. But diversity can still be found, especially in Albuquerque, where Gittings' camera has captured an eclectic mix of design influences from various historical periods including Territorial, Arts and Crafts and Santa Fe Style, as well as a touch of bright color borrowed from South of the Border. Hand-carved doors, wide portals (porches) and courtyards bright with flowers and fountains are part of an architectural continuum that links the present with our rich historical past. Even aging industrial buildings, now abandoned, in Gittings' images contain an evocative sense of presence, as if the air still rings with the suddenly-ceased sounds of rumbling rail cars and the press of busy crowds.

There is a desolate beauty, as well, in these silent structures. An old railroad terminal's strong, clean lines and symmetry may have arisen out of practicality, but now they remind us of an era that seems less complex, a time we might associate with concepts such as honesty, integrity and relative innocence. Those traits, along with craftsmanship, are similarly reflected in the perfect woodturning and graceful curve of a polished banister and the stately balance of a gable-design brick home. Gittings' choices of camera angles and framing, and his practiced use of shadow and light are central to the way a structure's finest qualities are perceived—even though the viewer may be unaware of how the eye is encouraged to move through an image or how timing has captured clouds or blue sky in just the right contrast to set off the planes of a building front.

These photographic skills, refined over decades and employed at will, are enhanced from time to time by the aid of synchronicity. That is, there are moments when the photographer follows an insistent nudge to stop where he is, look in a certain direction and take out his camera right now. These photos, it turns out, are almost invariably among his best. "What I've found is that there are times in life when I feel like the barrier between the conscious and unconscious mind is very thin and porous, and when I'm in these states the images really flow," Gittings reflects. "I consider them to be gifts of the spirit. But you can't make it happen. Such images come to you unexpectedly, almost as if they were seeking you out."

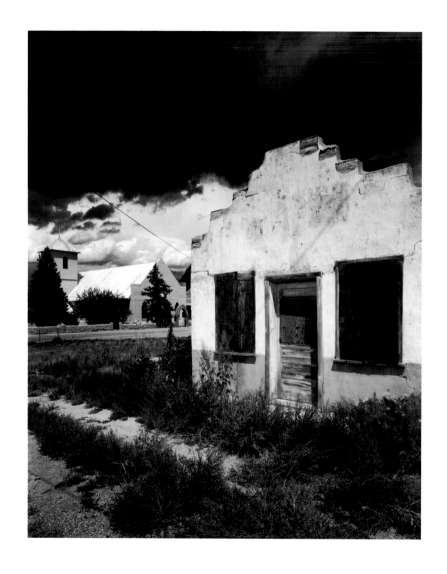

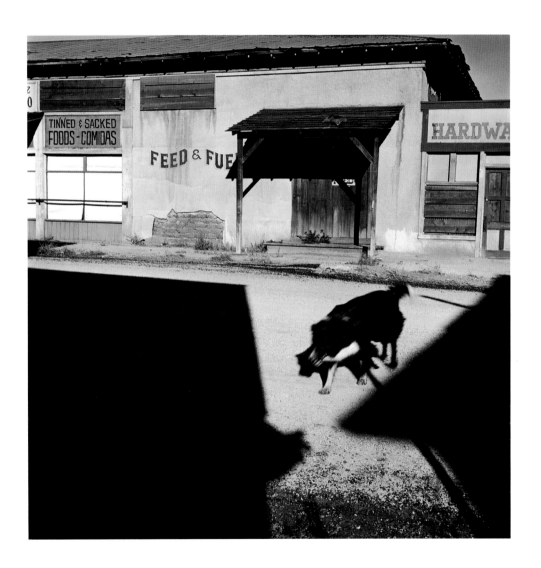

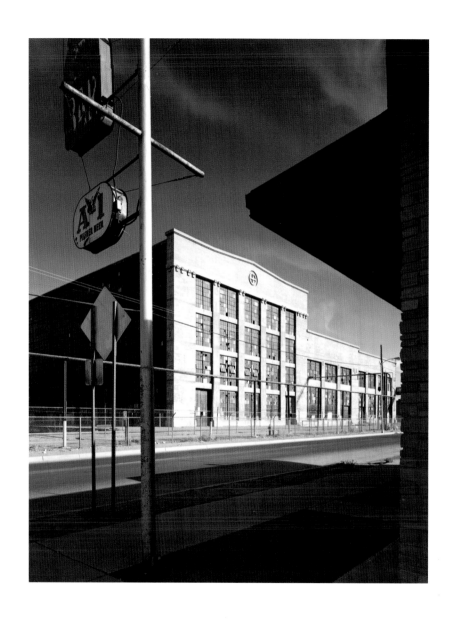

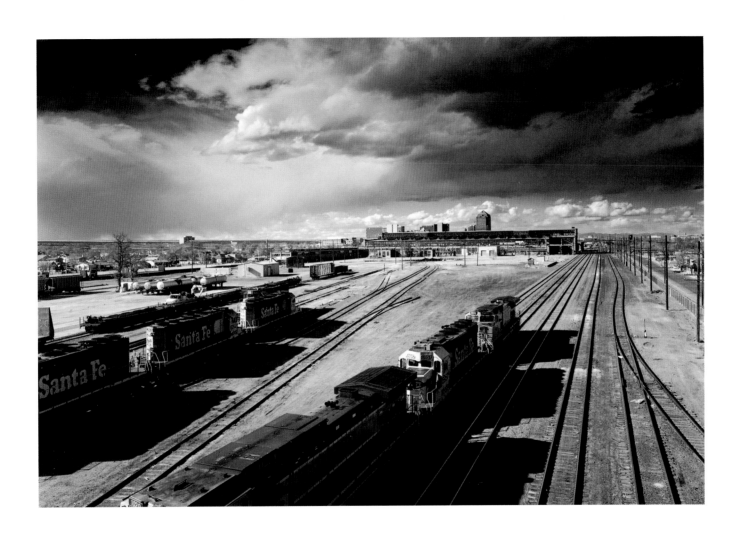

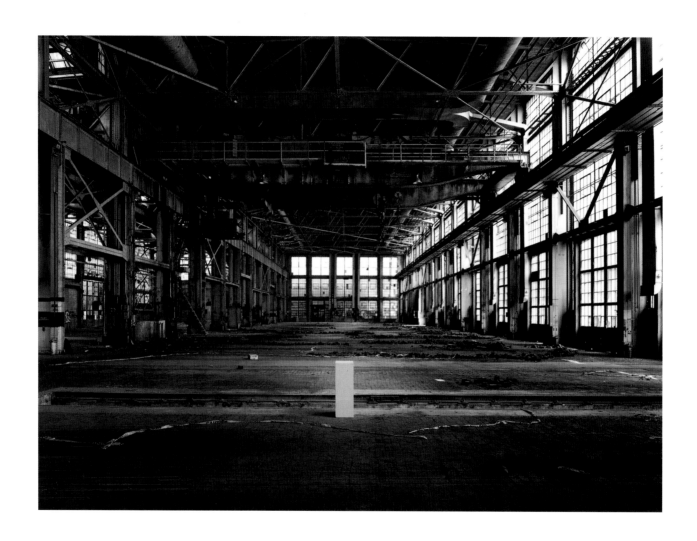

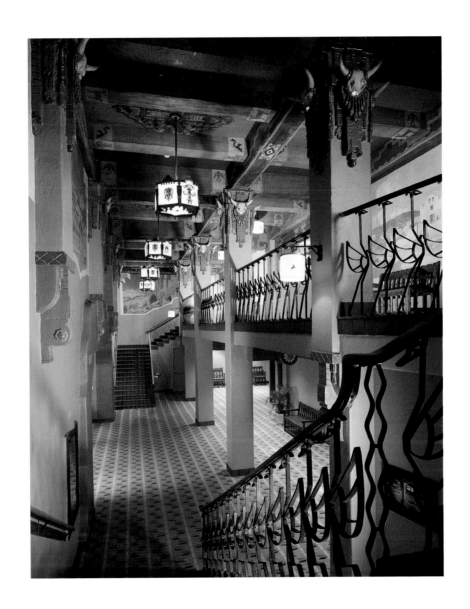

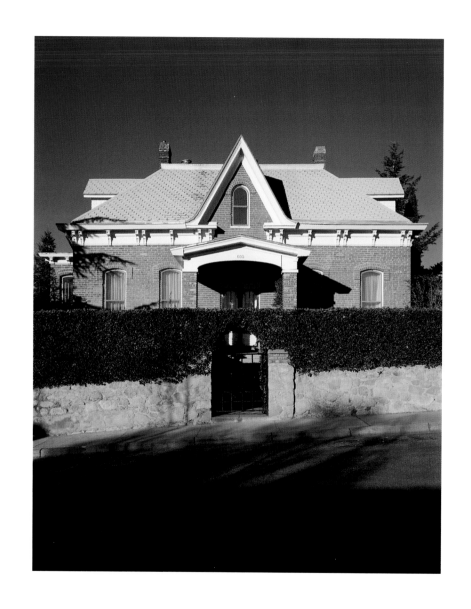

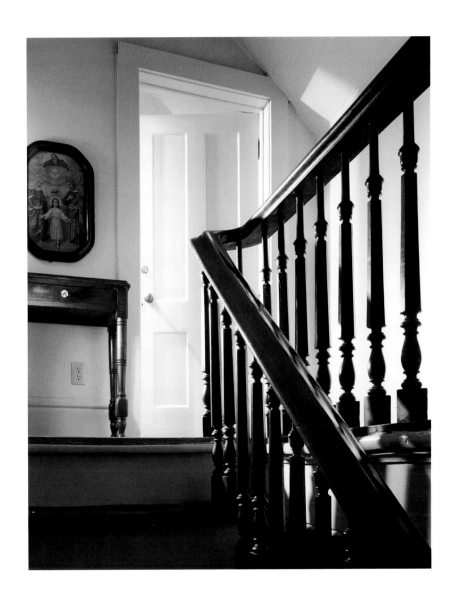

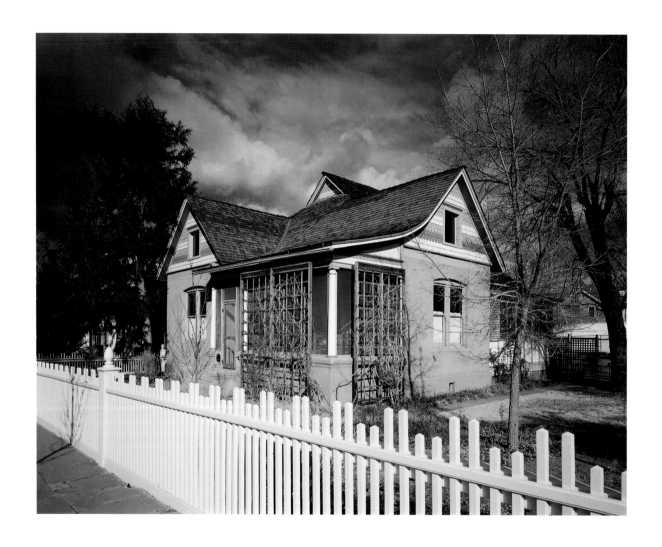

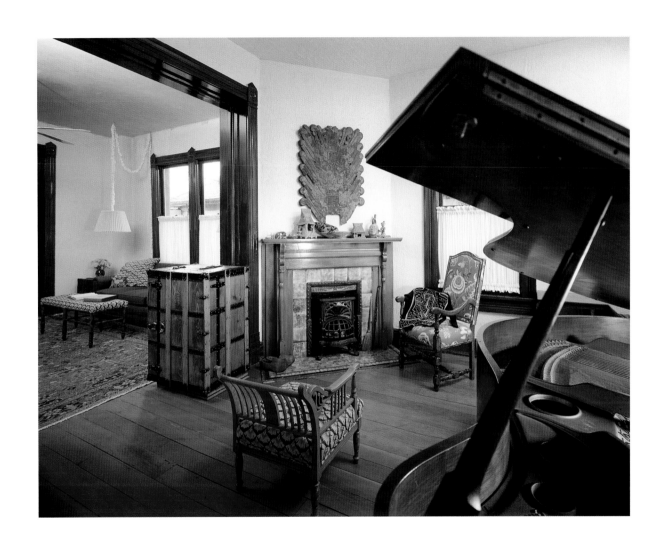

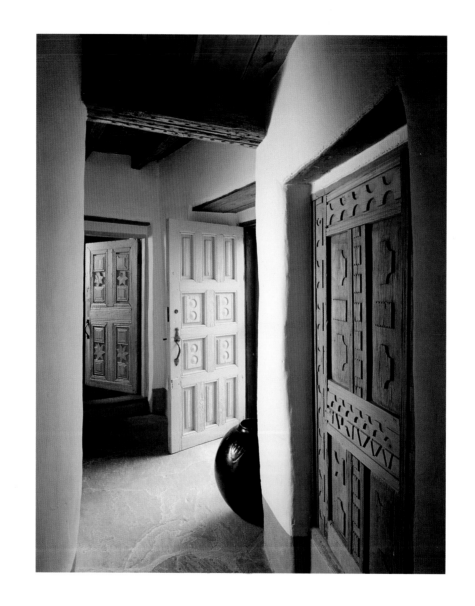

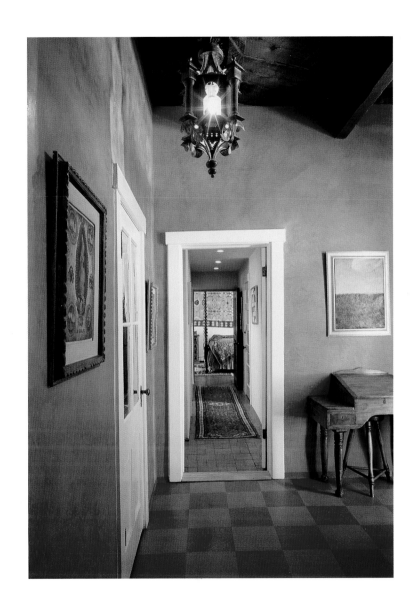

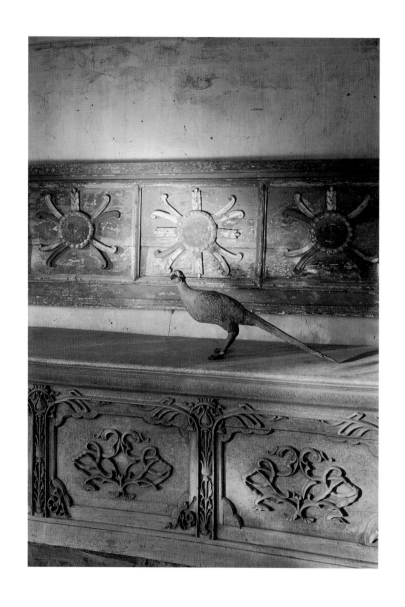

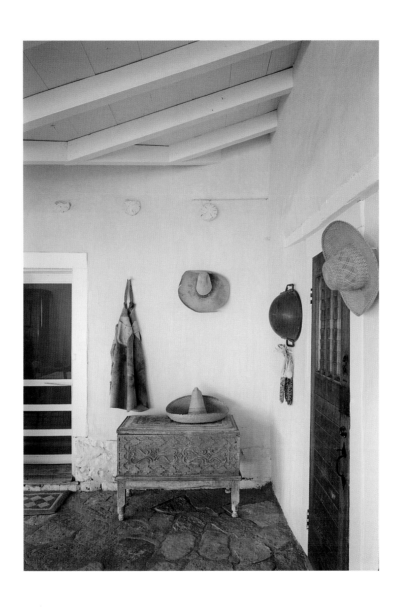

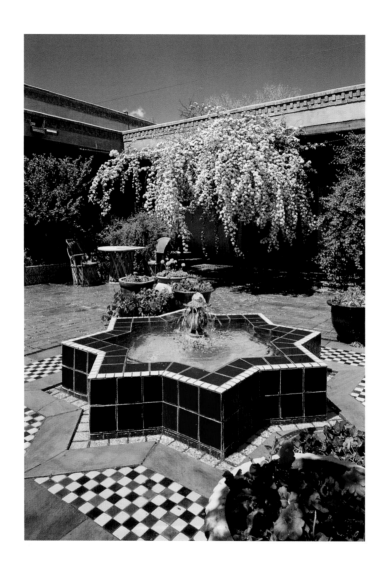

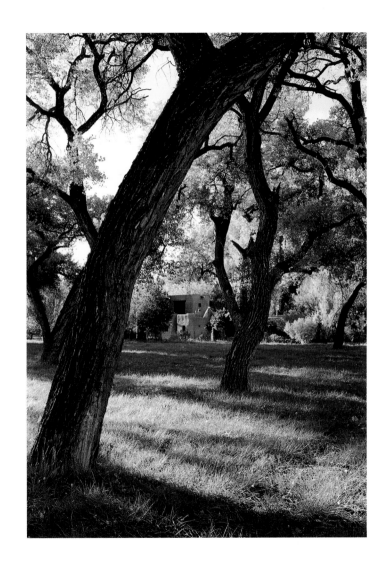

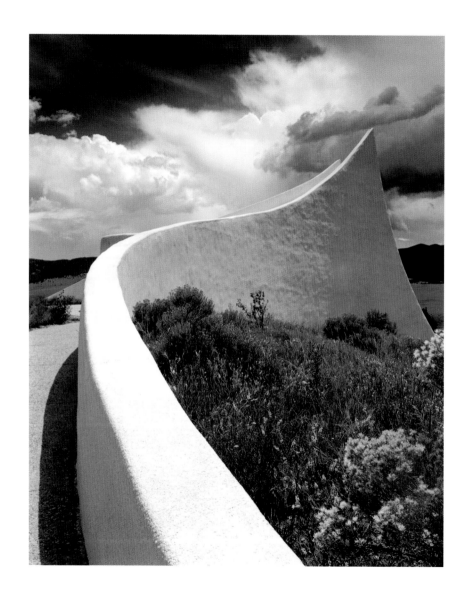

Modern Interpretations

TODAY, ARCHITECTURE CONTINUES TO EVOLVE IN THIS TIMELESS LAND. "NEW MEXICO HAS DEVELOPED SOME REALLY EXTRAORDINARY ARCHITECTS IN THE PAST 20 YEARS, AND THE QUALITY OF PROJECTS TO PHOTOGRAPH IS ON THE UPSWING AND IS CHALLENGING AND EXCITING," GITTINGS ASSERTS.

One overarching quality shared by many of these contemporary visionaries is the ability to seamlessly and creatively add to an evolving architectural idiom by working with materials and concepts that have been regionally common for centuries, which they now transform into striking contemporary forms.

The most obvious example of this is the updated use of indigenous building materials: adobe, stucco, stone and wood. Exposed large ceiling beams called *vigas*, with *latillas* (narrow timbers or boards) between them are traditional features elegantly at home in a 21st century design. Curved contemporary walls recall the shape of sacred spaces from early Puebloan times. Outdoor living areas and large and numerous windows let the land itself become an integral part of the architectural experience, as does solar orientation and the thoughtful placement of a structure within a lightly-altered natural building site. In all these ways, New Mexico's land and sky continue to permeate and shape the way our homes and other structures are conceived and built.

To create attractive, evocative, award-winning architectural photography is an art in itself—one that Gittings has spent many years refining, passing on to students and articulating in words through magazines and books. The fundamental aim, as he sees it, is to "passionately translate one aesthetic language—architecture—into another, photography." To be successful the photographer first must clearly grasp the formal and aesthetic issues expressed in a particular architectural design. These design features—for example, strong geometric angles and planes or highly sculptural shapes—are underscored in the photograph through techniques such as framing, cropping, lighting, color saturation and camera angle. In this way the spirit and soul of the design come through in the image itself. The biggest challenge to students of architectural photography, Gittings notes, is not technical mastery but learning to perceive the architect's vision and creatively express that vision in photographic form. Mastering technique alone, he believes, does no more than liberate the photographer's ability to see.

To the worthy lineage of photographers drawn to New Mexico over the years—Ansel Adams, Eliot Porter and David Muench among them—Gittings adds his own compelling visual interpretation of this extraordinary place, its land and structures. "Photography for me," he concludes, "is not a means of dispassionately observing the world, but a means of involvement through which I express my feelings for life."

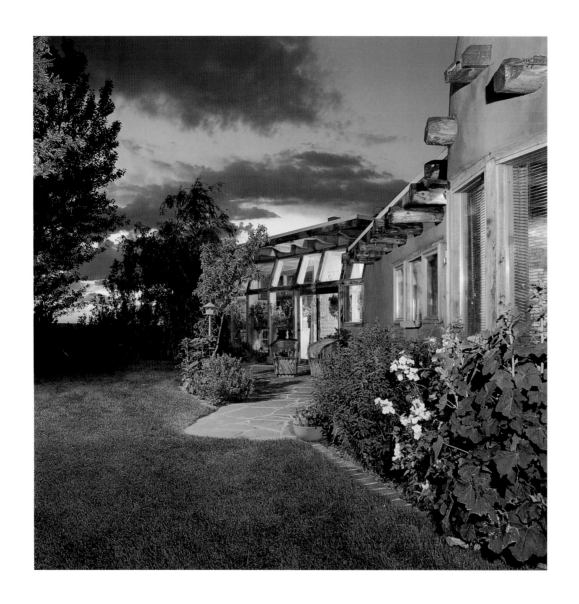

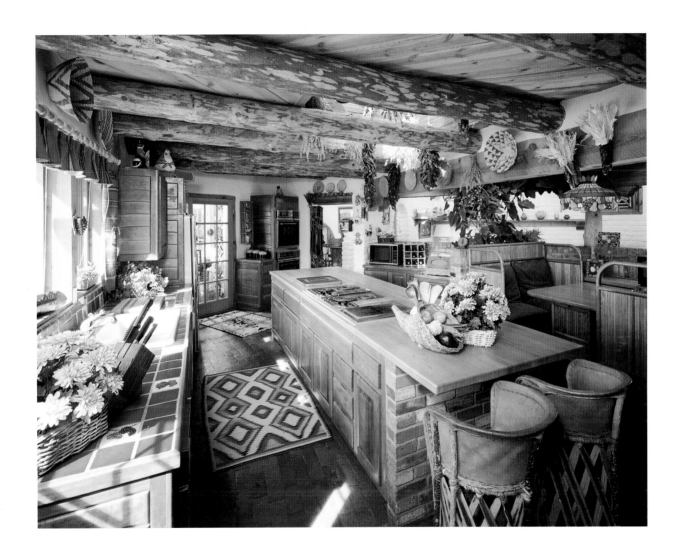

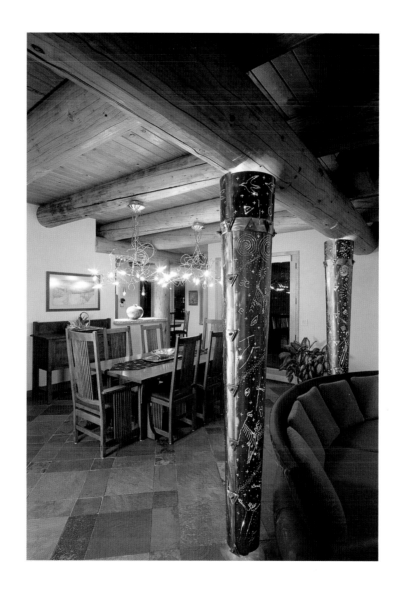

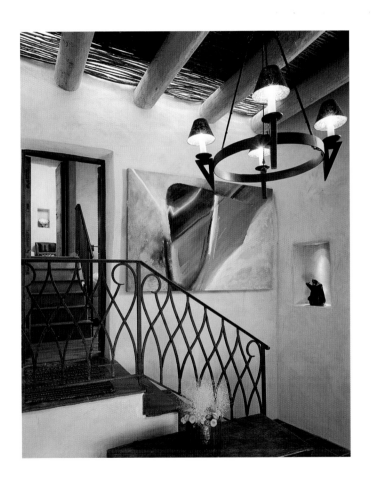

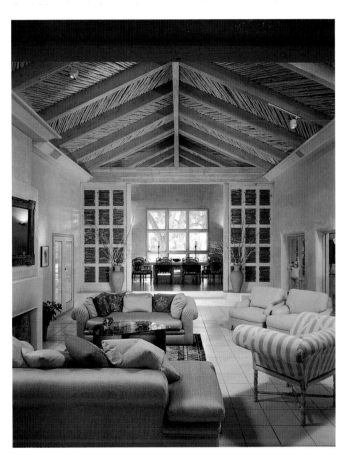

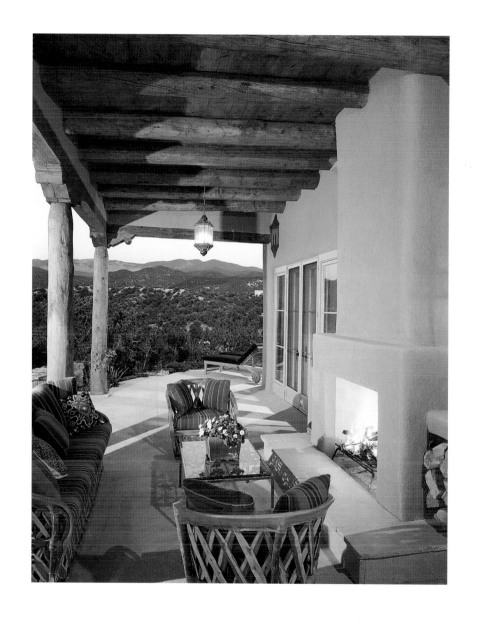

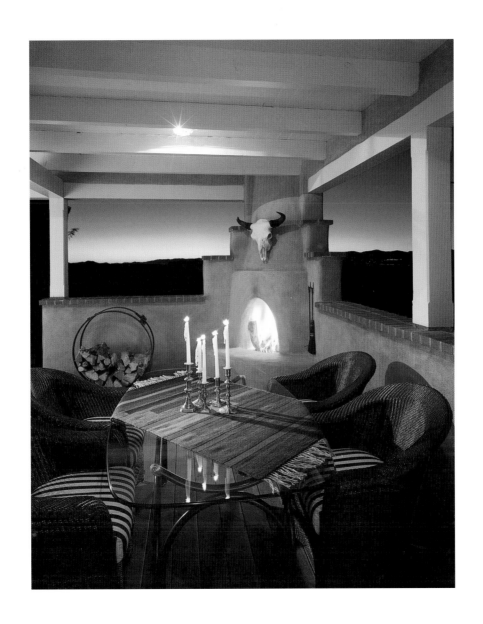

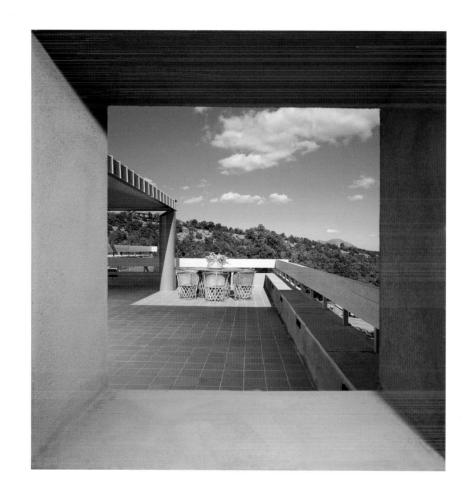

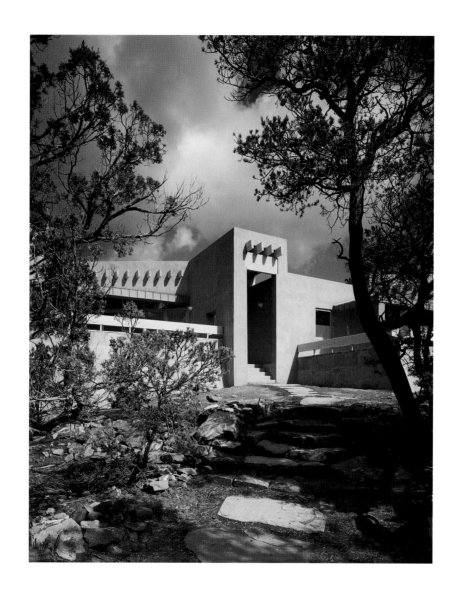

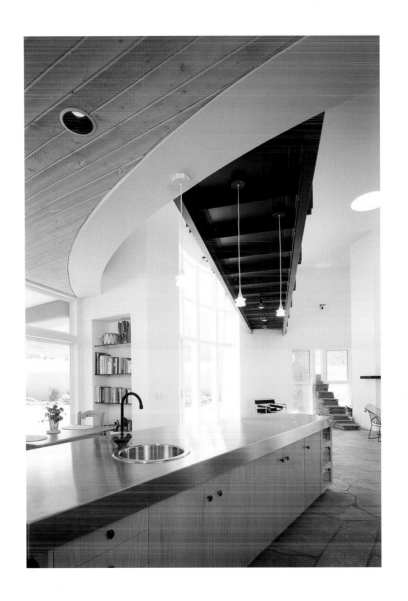

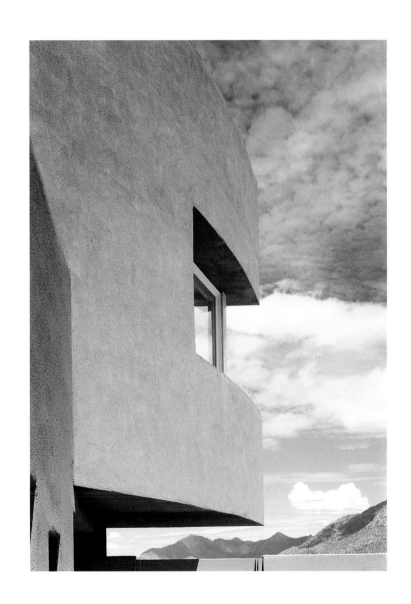

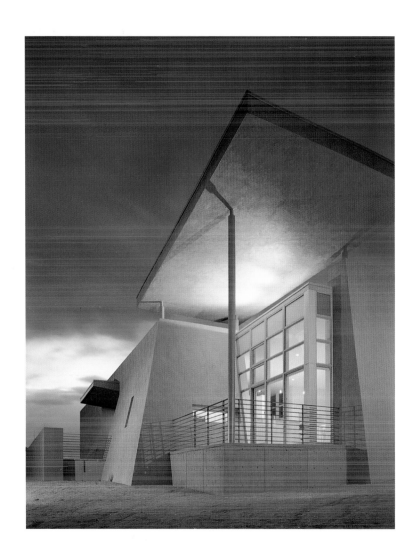

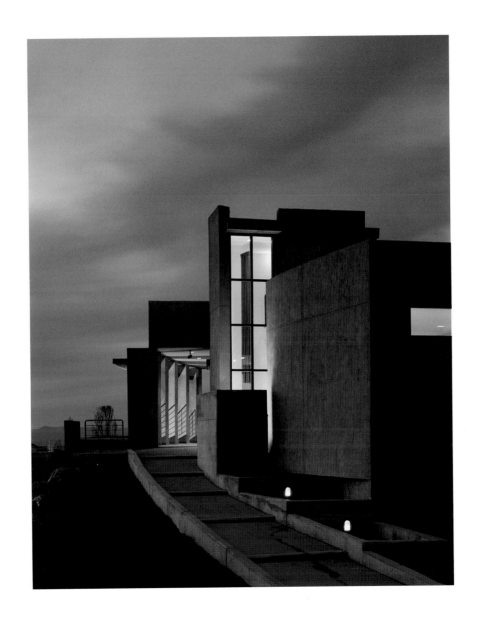

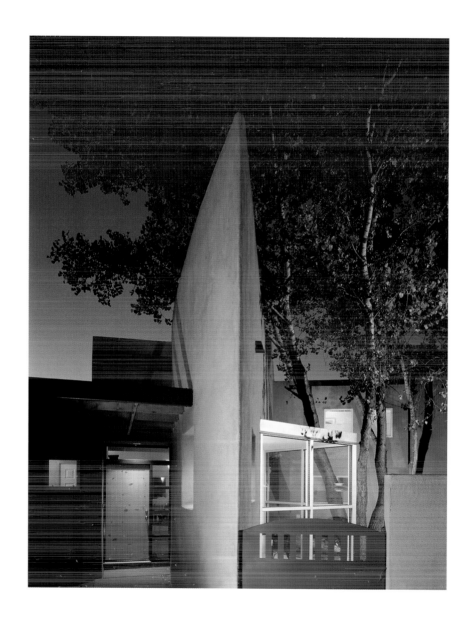

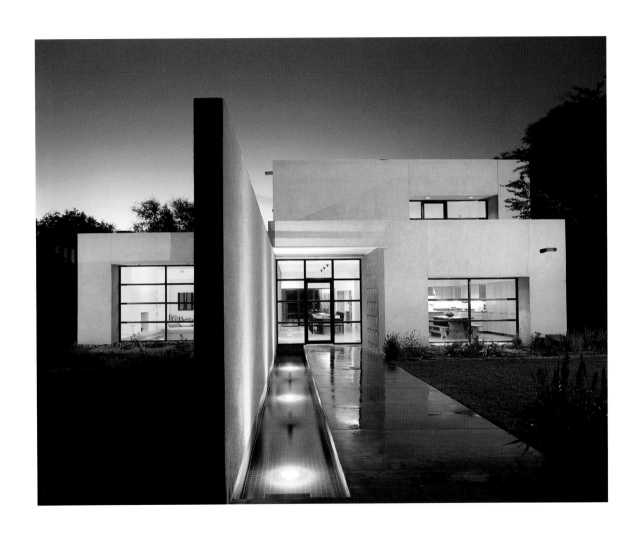

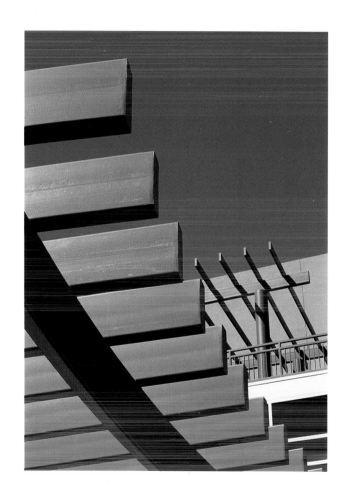

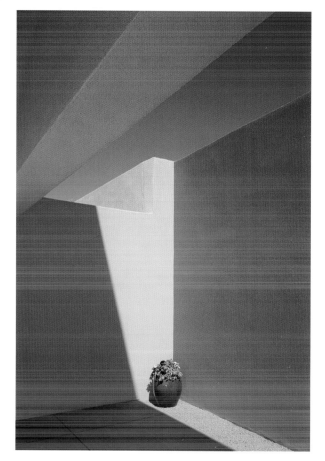

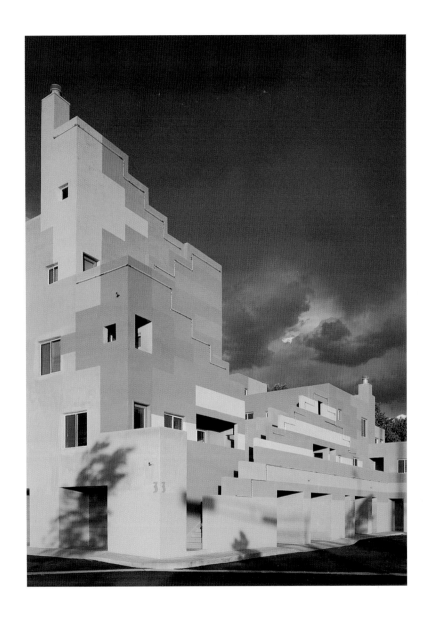

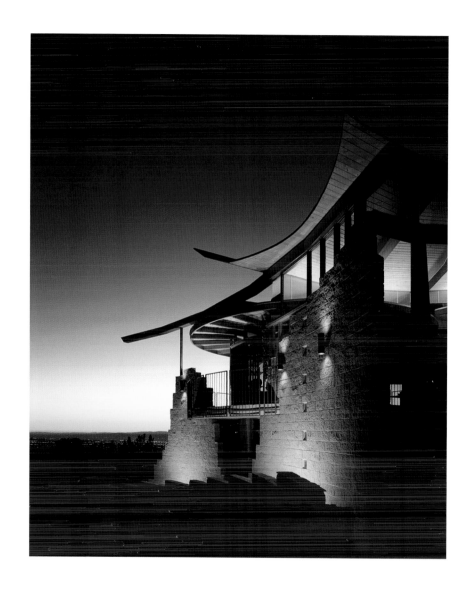

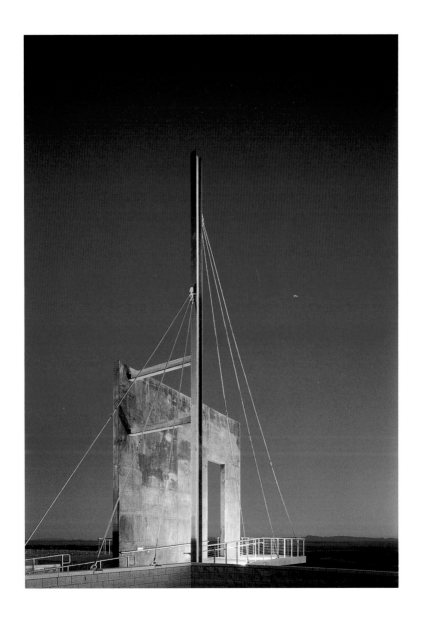

Vita

Photo: Abraham Aronow

KIRK EDWARD GITTINGS

Web site: www.gittingsphoto.com

Born: July 1, 1950, Anchorage, Alaska Territory

EDUCATION:

1983, Master of Fine Arts, Photography, University of
Calgary, Calgary, Alberta, Canada.

1972, Bachelor of University Studies, University of New
Mexico, Albuquerque, New Mexico.

EMPLOYMENT:

1970-PRESENT:

Fine Art Photographer: Numerous exhibitions. (See
Selected Exhibitions.)

Commercial Photographer: Architectural, editorial and
advertising work. (See Web site.)

1980-PRESENT:

Photography Instructor-University and Private Workshops:
The School of the Art Institute of Chicago (current), Univer-
sity of New Mexico, View Camera Magazine Workshops, Santa
Fe Photographic Workshops, Taos Art Association, Taos Institute
of the Arts, New Mexico Photographic Workshops, University of
Calgary (Canada) and New Mexico State University.

1982-PRESENT:

Photography Writer: *View Camera Magazine, Camera Arts
Magazine* and *Journal of American Photography.* (See
Articles by Kirk Gittings and Web site).

SELECTED EXHIBITIONS:

One Person-Traveling (Both exhibits owned and traveled by the
Albuquerque Museum.)

1988-PRESENT:

Chaco Body: Museum of Northern Arizona, Flagstaff, Ariz.;
Albuquerque Museum, Albuquerque, N.M.; Graham Gallery,
Albuquerque, N.M.; University of New Mexico, Center for
Southwest Research, Albuquerque, N.M.; University of Arizona,
Tempe, Ariz.; Farmington Museum, Farmington, N.M.;
Albuquerque Convention and Visitors Bureau Fine Art Gallery,
Albuquerque, N.M.

1990-PRESENT:

Monuments of Adobe: Albuquerque Museum, Albuquerque, N.M.;
Mabee-Gerrer Museum of Art, Shawnee, Okla.; University of New
Mexico, Albuquerque, N.M.; Los Alamos Museum, Los Alamos,

N.M; Museum of the Archdiocese of Santa Fe, Santa Fe, N.M.; Salinas Pueblo National Monument, Mountainair, N.M.

SELECTED PUBLICATIONS:

Limited Edition Portfolios:

1987, *Chaco Body*, limited edition portfolio of 24 original
 gelatin silver prints with poems by V.B. Price.

Monographs:

1991, *Chaco Body*, poetry by V.B. Price, Art Space Press,
 distributed by University of New Mexico Press and
 Friends of Photography.

Books Illustrated:

2003 and 1992, *A City at the End of the World*, text by V.B.
 Price, University of New Mexico Press.

1991, *Monuments of Adobe: The Religious Architecture
 of Northern New Mexico*, text by Michael Miller, Taylor
 Publishing.

Portfolios of Images in Periodicals:

2003, "A Longing Look," *Mirage Magazine*.

2003, "The Fine Print: Photography by Kirk Gittings," *New
 Mexico Magazine*.

2002, "Kirk Gittings," *Through the Lens, World Architectural
 Photographers*, Images Pub., Australia.

1997, "Kirk Gittings: New Mexico's Mythical Places,"
 cover story, *View Camera Magazine*.

1983, "Portfolio: Kirk Gittings," *Journal of American
 Photography*.

Articles by Kirk Gittings:

2003, "A Workshop for All Mediums," *Camera Arts*.

2000, "Teaching Architectural Photography," *View Camera*.

1990, "Architecture in Black and White," *View Camera*.

1988, "Introduction to Photographing Historic Properties,"
 Forum Information Series, the National Trust for Historic
 Preservation and Society for Photographic Education.

1986, "Photography: Creative Empathy," *Journal of American
 Photography*.

1984, "Palette in Black and White Photography," *Journal of
 American Photography*.

Articles about Kirk Gittings:

2003, "A Longing Look," *Mirage Magazine*.

2003, "The Fine Print: Photography by Kirk Gittings," *New
 Mexico Magazine*.

2000, "In the Darkroom with Kirk Gittings," *View Camera*.

1998, "Hotshots-Kirk Gittings," *Sources & Design*.

1997, "Kirk Gittings: New Mexico's Mythical Places,"
 View Camera.

1992, "New Mexico's Historic Churches," *Southern Accents*.

Published Commercial and Editorial Images:

1978-Present, Photography has appeared in the following:

Magazines:

Ambiente (Berlin, Germany); *Architecture, Architectural Record,
America West Airlines Magazine, Art in America, Camera Arts,*

Contract, Custom Builder, Designer's West, Dwell, Fine Homebuilding, Forbes Magazine, Hauser (Hamburg, Germany), *Historic Preservation, New Mexico Magazine, Nikkie Architecture,* (Tokyo; Japan), *Out, Phoenix House and Garden, Progressive Architecture, Residential Architecture, Santa Fe Trends, Saturday Evening Post, Southern Accents, Sources & Design, Su Casa, Sunset Magazine, The Santa Fean, Ventanas del Valle* and *View Camera.*

Books:

100 of the World's Best Houses by Catherine Slesson, Images Pub. (Australia); *Anasazi Architecture*, Baker H. Morrow/V.B. Price, University of New Mexico Press; *Artists at Home* by Emily Drabanski, *New Mexico Magazine*; *Desert Architecture* by Tamara Hawkinson, Northland Press; *International Architecture Yearbook, Vol. 1-7*, (Australia); *Joan Kohn's It's Your Kitchen* by Joan Kohn, Bulfinch; *New Country Houses* by Dominick Bradbury, Laurence King, Abbeville Press (England); *Old Town: Albuquerque, New Mexico*, Albuquerque Museum; *Pueblo Style and Regional Architecture* by Nicholas C. Markovich, Wolfgang E. Preiser and Fred G. Sturm, Van Norstand Reinhold; *Rio Grande High Style: Furniture Craftsmen* by Elmo Baca, Gibbs Smith; *Santa Fe Design* by Elmo Baca and Suzanne Deats, Ashley Books; *Santa Fe Fantasy: Quest for the Golden City* by Elmo Baca, Clear Light Books; *The Chaco Trilogy*, V.B. Price, La Alameda Press; *The Culture of Tourism, The Tourism of Culture*, edited by Hal Rothman, University of New Mexico Press; *Through the Lens, World Architectural Photographers*, Images Pub. (Australia); *Western Design* by M.J. Van Deventer and *Using the View Camera* by Steve Simmons, Watson-Guptill Publications.

Video Productions:

2003, Co-director of Video Photography, Millennium Fountain Project. School of the Art Institute of Chicago and City of Chicago, Ill.

1991, "Chaco Body" with V.B. Price. Directed by Michael Kamens, KNME-TV, Albuquerque, N.M. Full one-hour version of 1990 program aired nationally on PBS.

1990, "Chaco Body" with V.B. Price. Directed by Michael Kamens, a 20-minute *Colores* segment on KNME-TV, Albuquerque, N.M.

GRANTS:

2001-1982, Many grants including those from the following organizations: The National Endowment for the Arts, Kodak USA, The McCune Foundation, The Albuquerque Conservation Association, The New Mexico Community Foundation, The Polaroid Corporation-Artist Support Group, Calumet Photographic and University of Calgary.

1979-Present, Co-wrote and participated in many grant projects including those supported by the following: The Getty Foundation, NEA Design Arts Division and New Mexico Humanities Council.

(Editor's Note: Kirk Gittings' photography has been widely published around the world. He's received numerous awards and honors. For a more extensive vita, please see the Web site www.gittingsphoto.com.)

Contributors

GUSSIE FAUNTLEROY IS THE AUTHOR OF *ROXANNE SWENTZELL: EXTRAORDINARY PEOPLE* (2002) AND *JOEL GREENE: NEW MEXICO MODERNIST* (2004), BOTH PART OF *NEW MEXICO MAGAZINE*'S ARTIST SERIES. She writes regularly on the arts for national and regional publications, including *Southwest Art*, *Art & Antiques*, *New Mexico Magazine*, *American Craft* and *Native Peoples Magazine*, as well as being a book reviewer and weekly columnist for *The New Mexican* newspaper in Santa Fe, where she has lived for many years. With a lifelong interest in both photography and architecture, she is pleased to help present a look at how beautifully the two can intersect.

V.B. PRICE IS A POET, COLUMNIST, EDITOR AND TEACHER IN THE UNIVERSITY OF NEW MEXICO'S HONORS PROGRAM. HIS COLUMN ON POLITICS AND THE ENVIRONMENT HAS APPEARED EVERY WEEK, IN VARIOUS PUBLICATIONS, SINCE 1971. Price's more than a dozen books include *The Oddity*, a novel; *Albuquerque: A City At The End of the World*, nonfiction; *In Company: An Anthology of New Mexico Poets Since 1960*, co-editor; *Anasazi Architecture and American Design*, co-editor; and *Chaco Body*, a collection of poetry and photographs with Kirk Gittings.

Acknowledgements

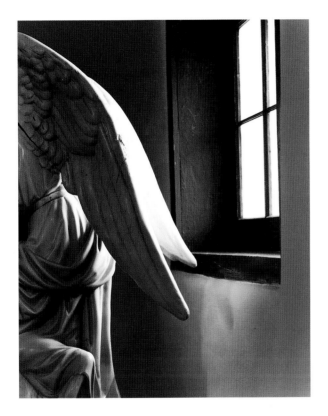

SPANNING A MEMORABLE 32 YEARS, THE SAGA OF THESE IMAGES BRINGS TO MIND A LEGION OF EXTRAORDINARY PEOPLE.

This book is dedicated to the one person whose unqualified support helped me to survive the ups and downs of an artist's life, my dear mother, Bernadine. I would also like to offer my heartfelt thanks to: my lovely wife, Victoria; talented children Gabriel, Erica and Ashleigh; the Varela family and to my compadres V.B. Price, Alan Labb and Steve Simmons who have accompanied, inspired and sometimes barely endured my manic journey with amazing patience and humor.

I also wish to sincerely thank author Gussie Fauntleroy and the *New Mexico Magazine* staff whose faith in my vision helped launch and sustain my career, especially publisher Ethel Hess, editor Emily Drabanski, designer Bette Brodsky, art director John Vaughan and photo editor Steve Larese. Special thanks also to the Albuquerque Museum for its generous exhibition of my work over the years in particular director James Moore, curators of art Douglas Fairfield and Ellen Landis and former curator of exhibits Bob Woltman.

The images also invoke the presence of these friends: professors Jim Kraft, Rod Lazorik, Jane Kelley and Art Nishimura; magazine publishers Charles Poling and Bob Skolnick; art director Sarah Friedland; assistants Jim Hunter, Anthony Richardson and James Burbank; gallery owner Paul Paletti; writer Michael Miller; archivist Marina Ochoa; Dr. Michael Keslin; architectural historians Elmo Baca, Chris Wilson and Timothy Wittman; the late builder Robert Slattery; and members of the American Institute of Architects whose works inspired much of this book.

—Kirk Gittings